EASY COLOR, CUT, AND FOLD
COLORFUL CATS

30 CREATIVE CUT-OUT
PROJECTS FOR EVERYONE

ILLUSTRATED BY **MARY BETH CRYAN**

Racehorse Publishing

Racehorse Publishing books may be purchased in bulk at special discounts for sales promotion, corporate gifts, fund-raising, or educational purposes. Special editions can also be created to specifications. For details, contact the Special Sales Department, Skyhorse Publishing, 307 West 36th Street, 11th Floor, New York, NY 10018 or info@skyhorsepublishing.com.

Racehorse Publishing™ is a pending trademark of Skyhorse Publishing, Inc.®, a Delaware corporation.

Visit our website at www.skyhorsepublishing.com.

10 9 8 7 6 5 4 3 2 1

Cover design by Michael Short
Cover artwork by Mary Beth Cryan

ISBN: 978-1-944686-93-2

Printed in China

INSTRUCTIONS

1. Color the cat.

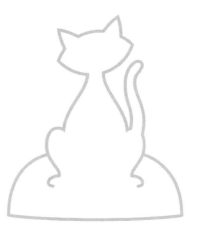

2. Cut out the cat along the thick gray lines.

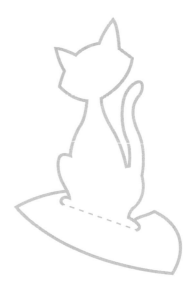

3. Valley fold along the dashed gray line.

 valley fold 90°

4. Sit your cat on a flat surface and enjoy!

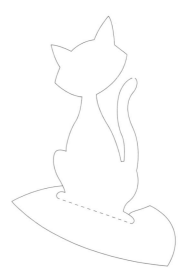

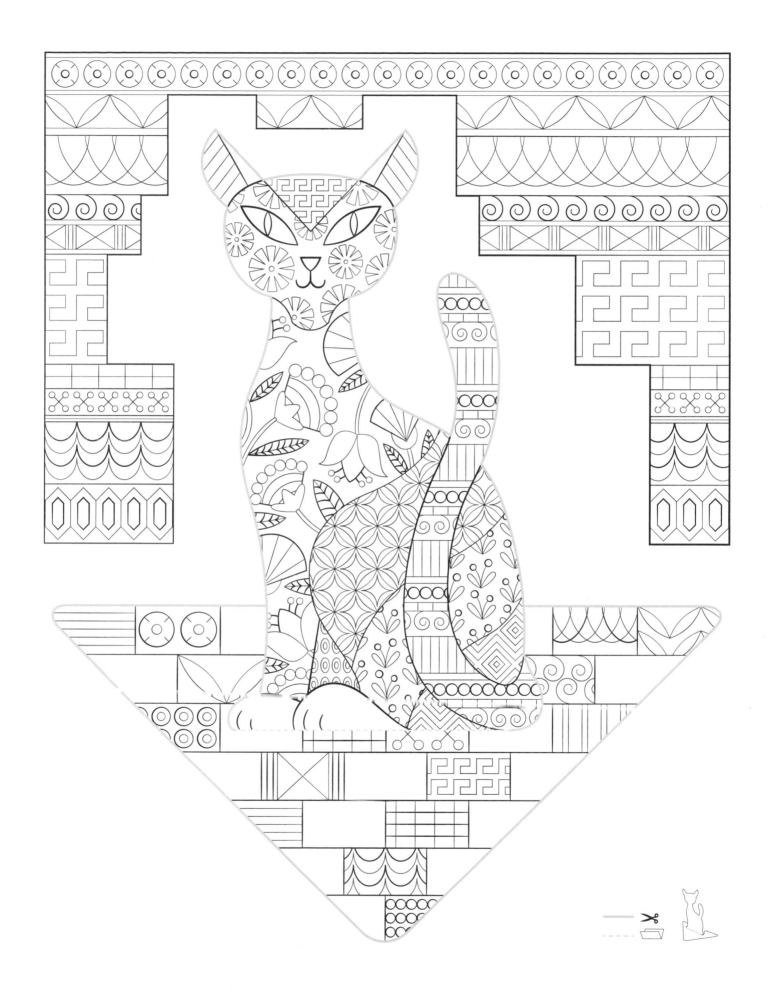

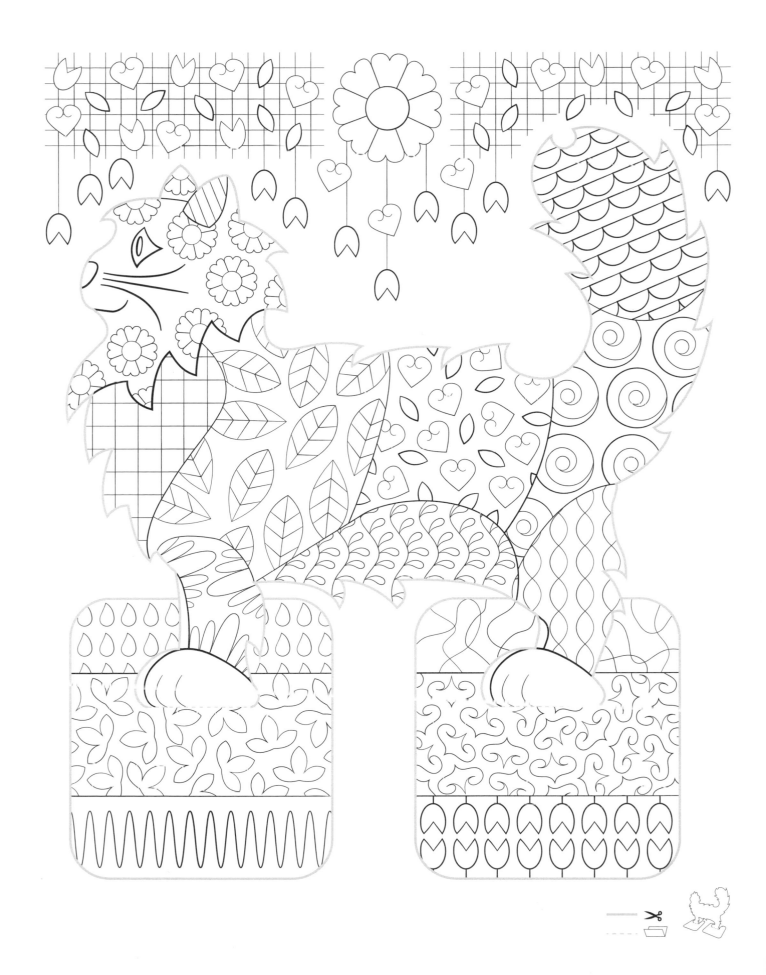

4

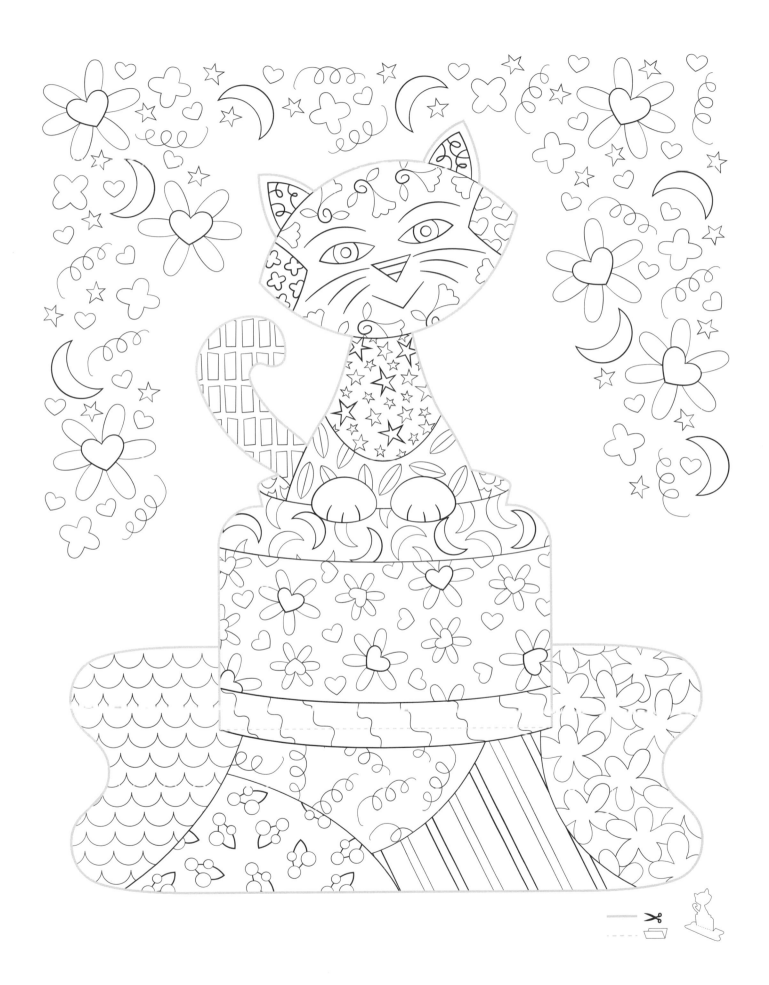

5

5

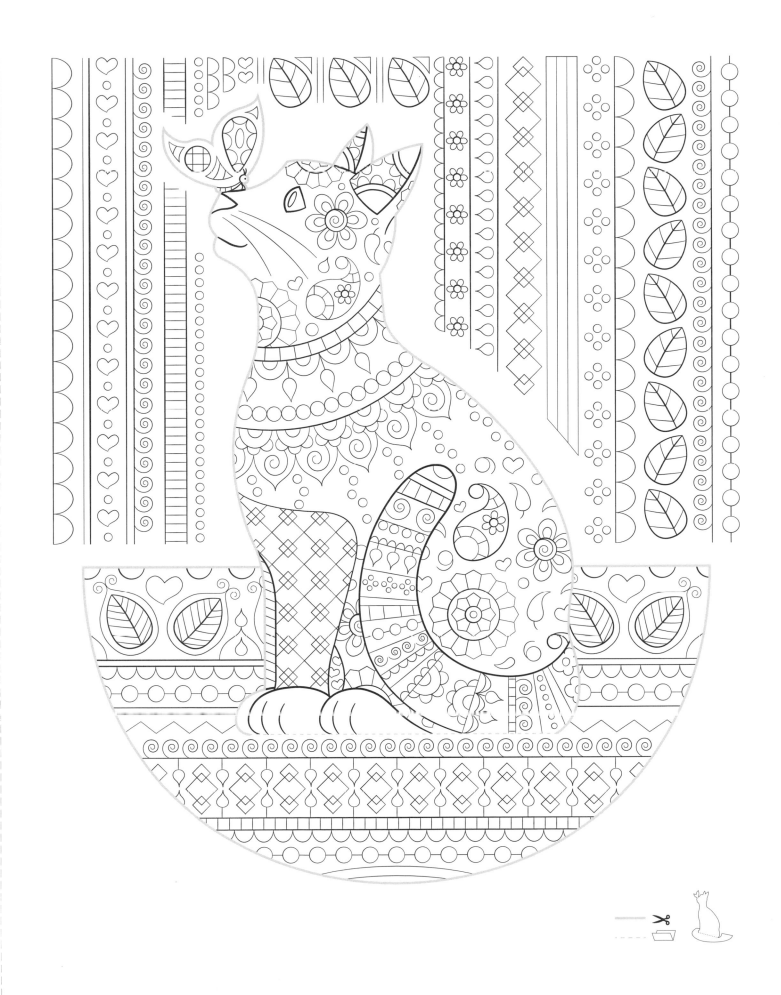

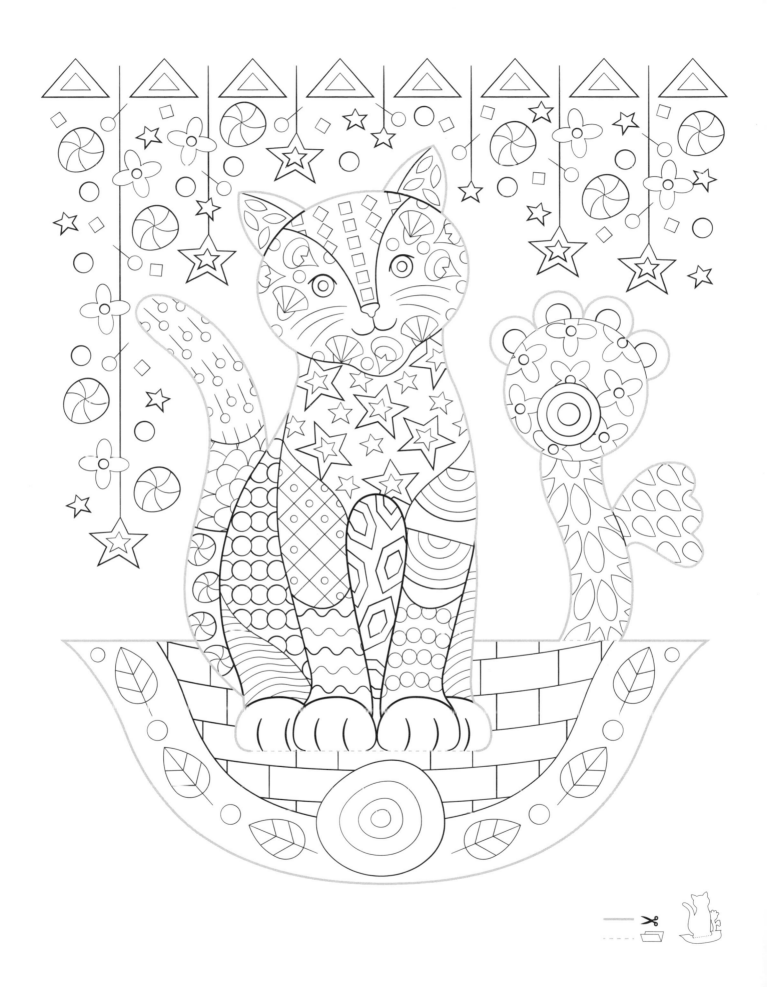

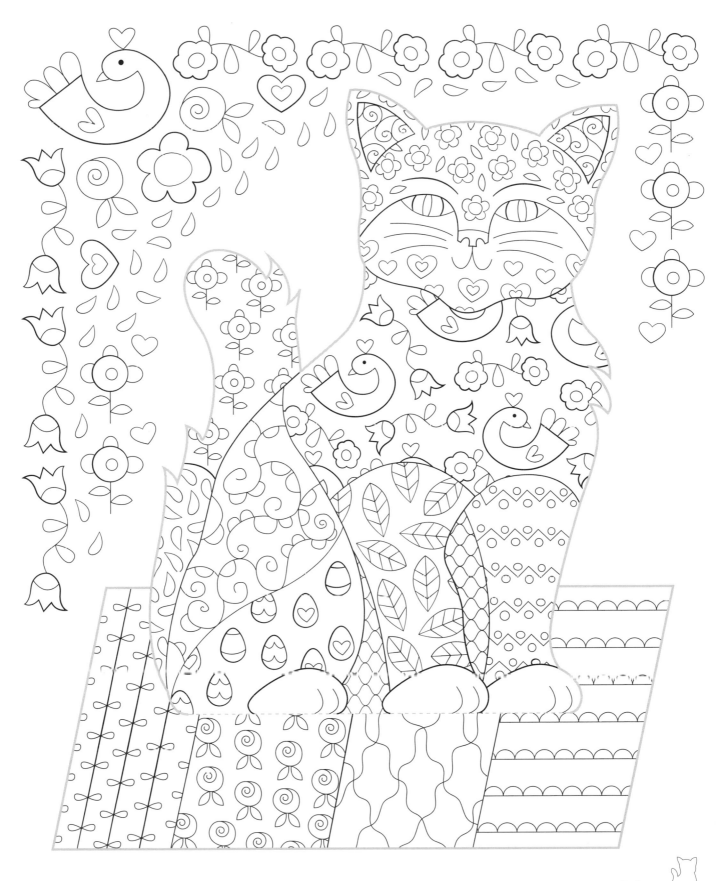

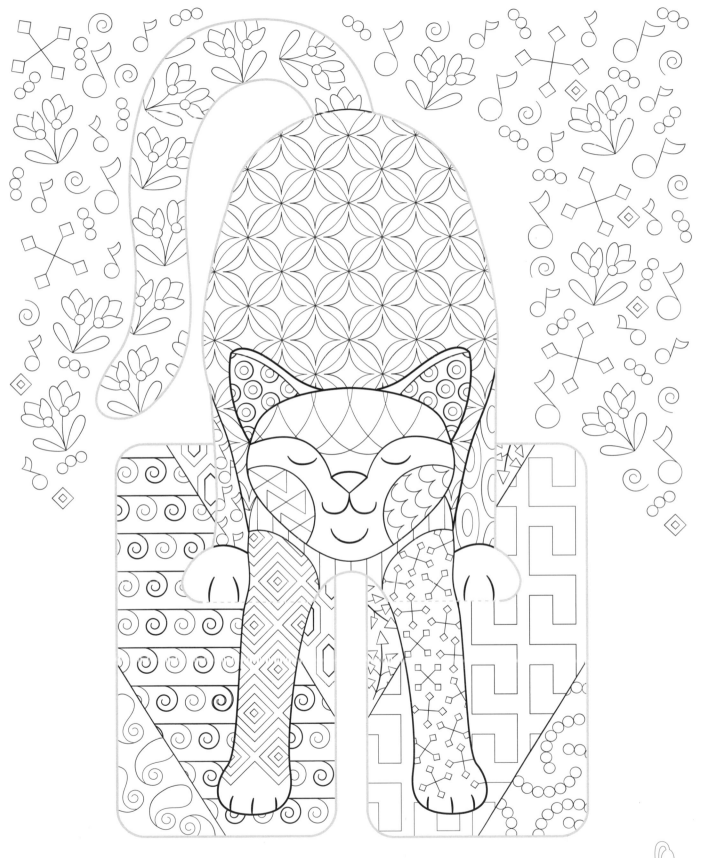

← 9

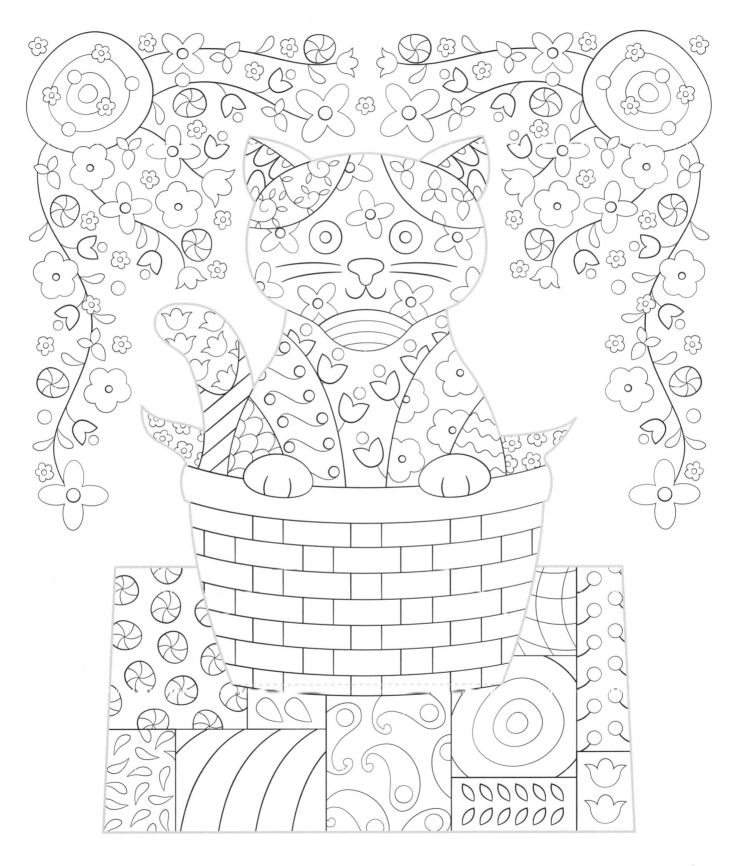

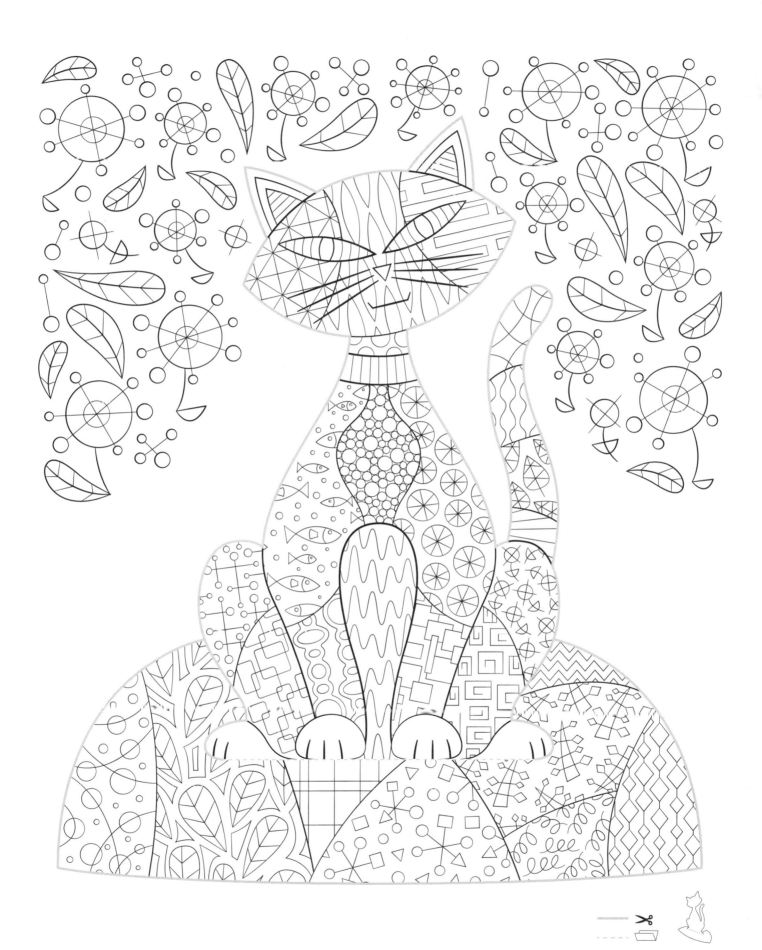

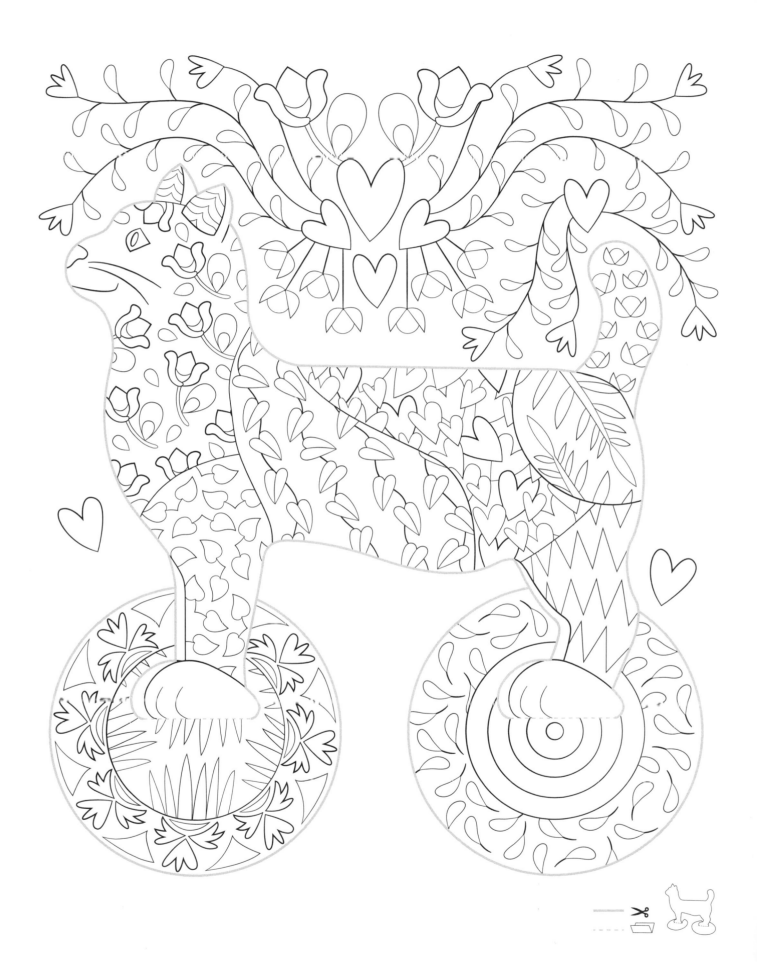

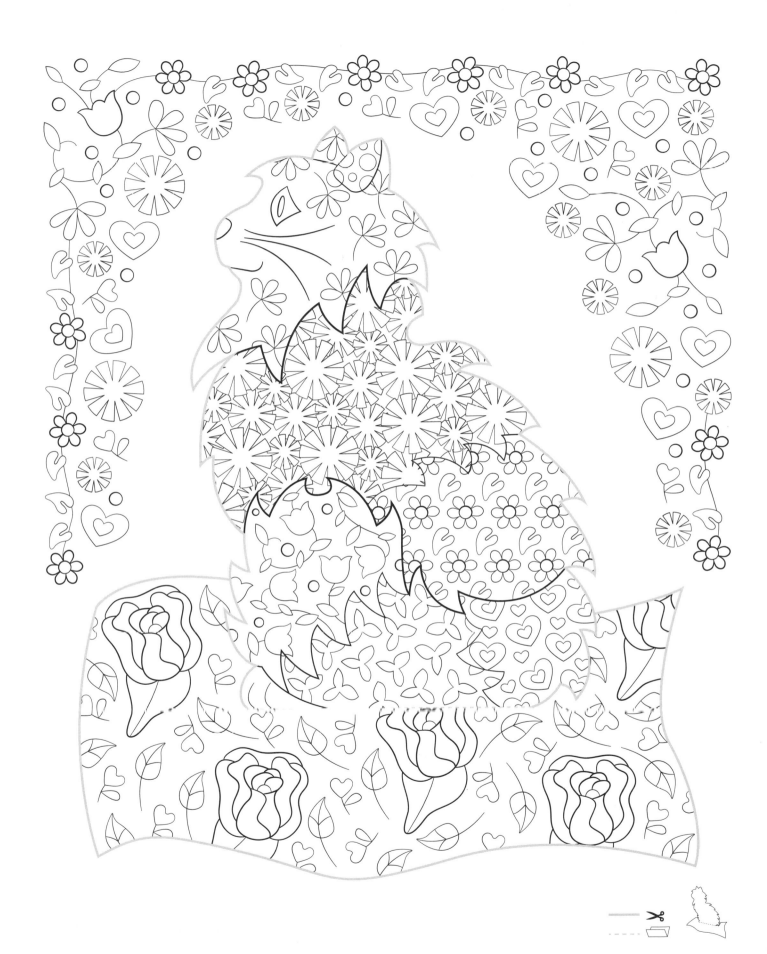

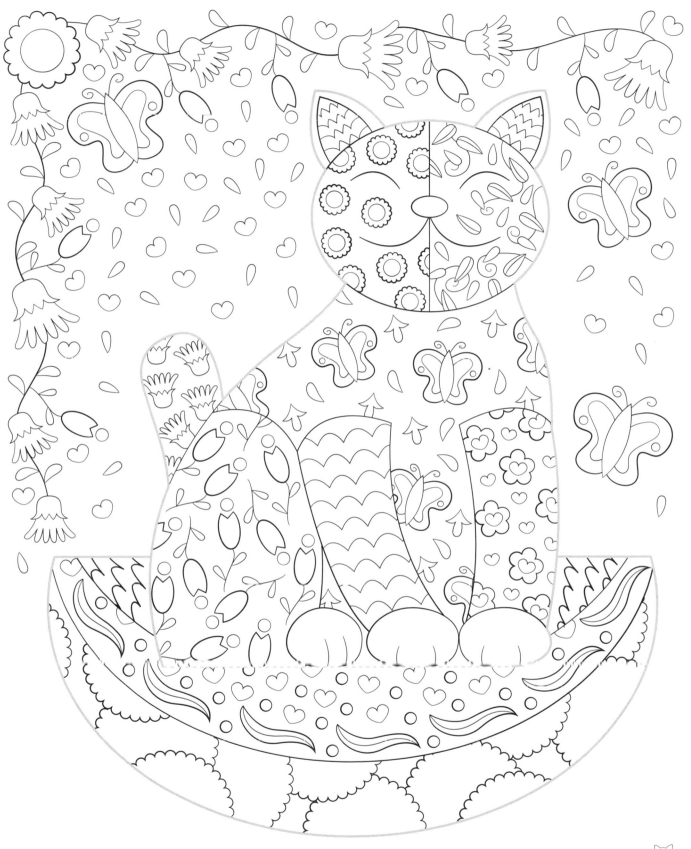

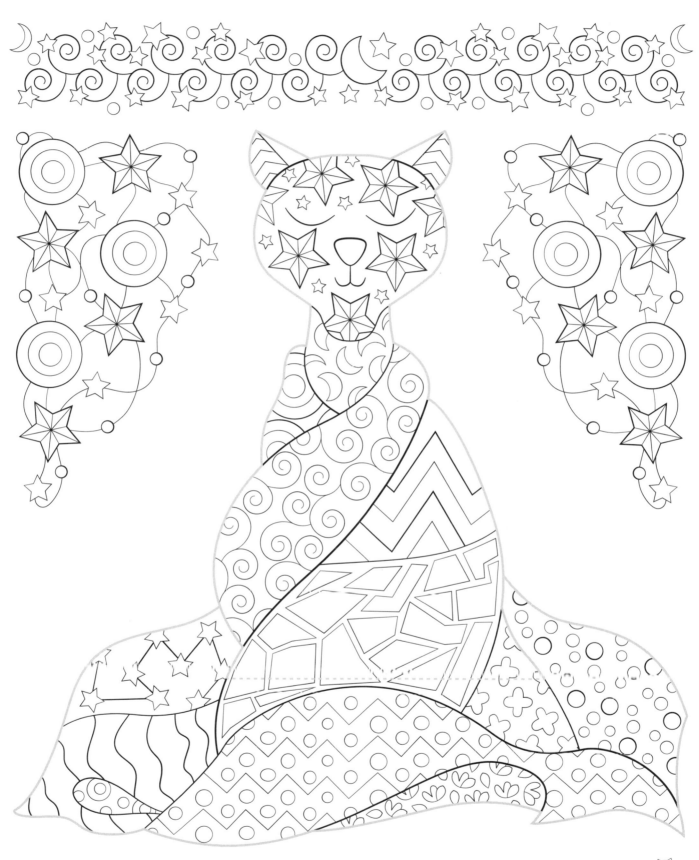

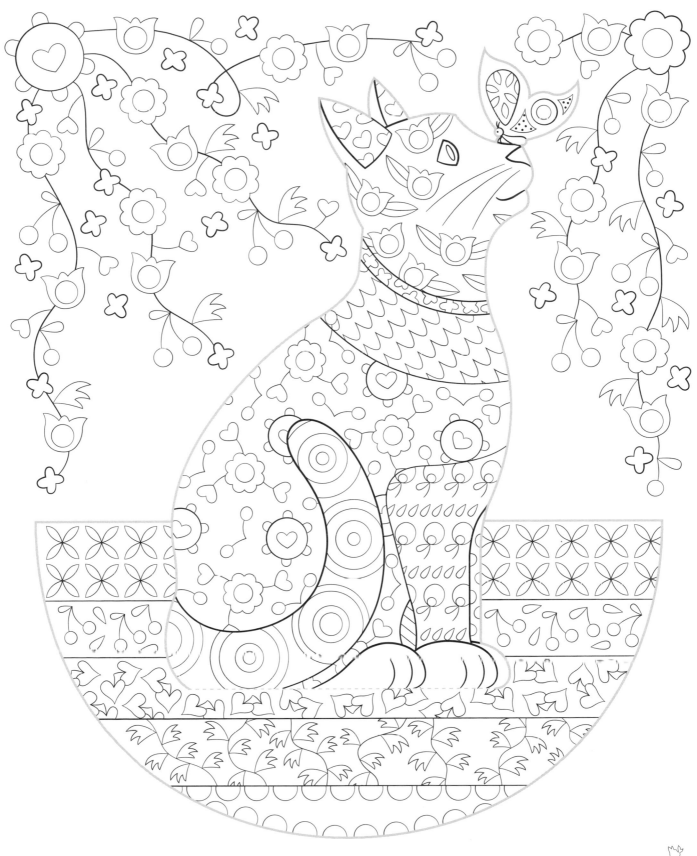

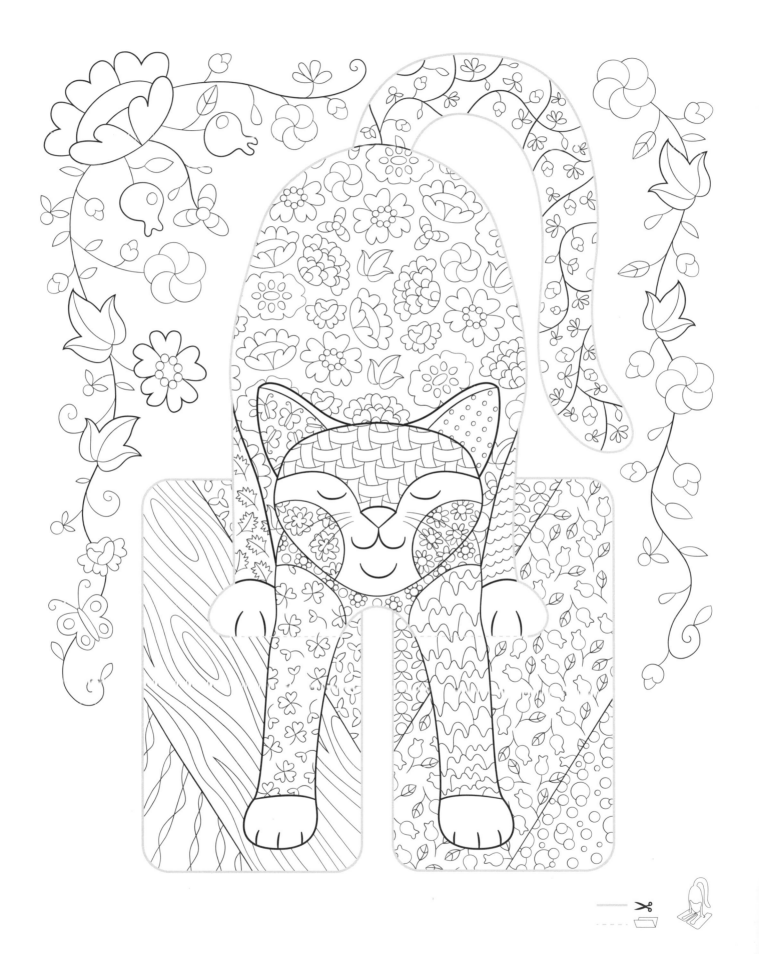

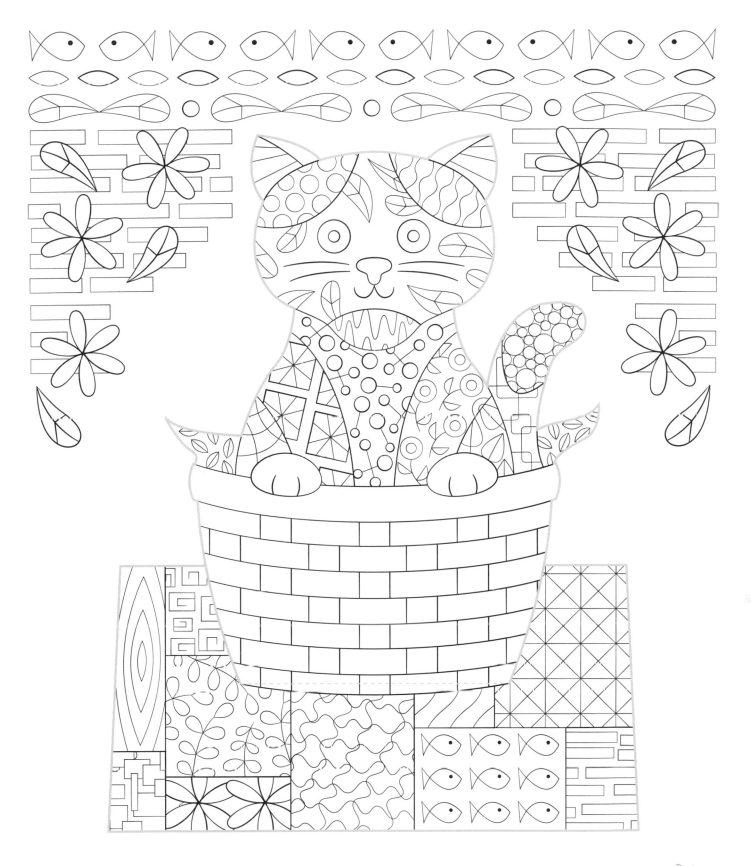

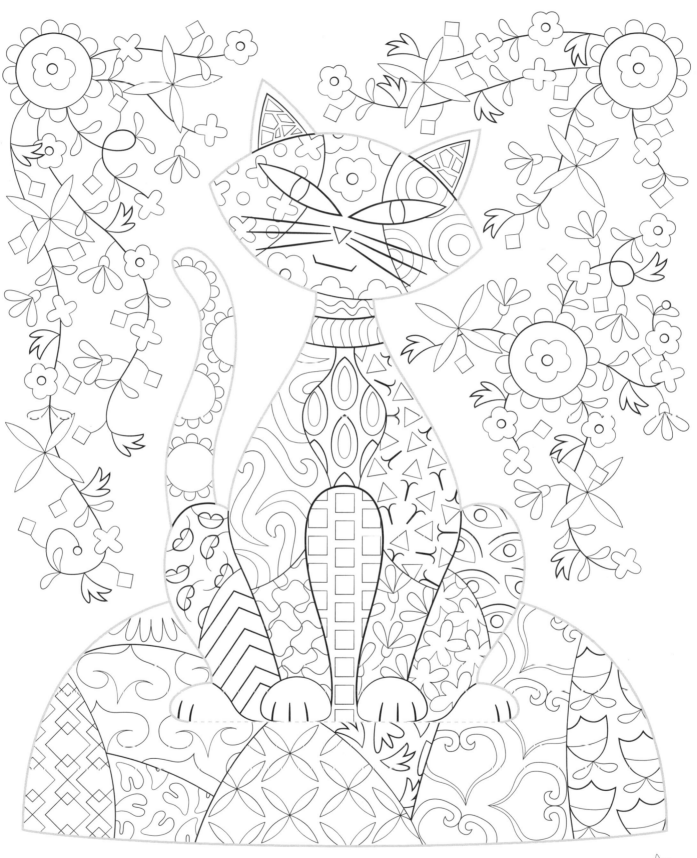

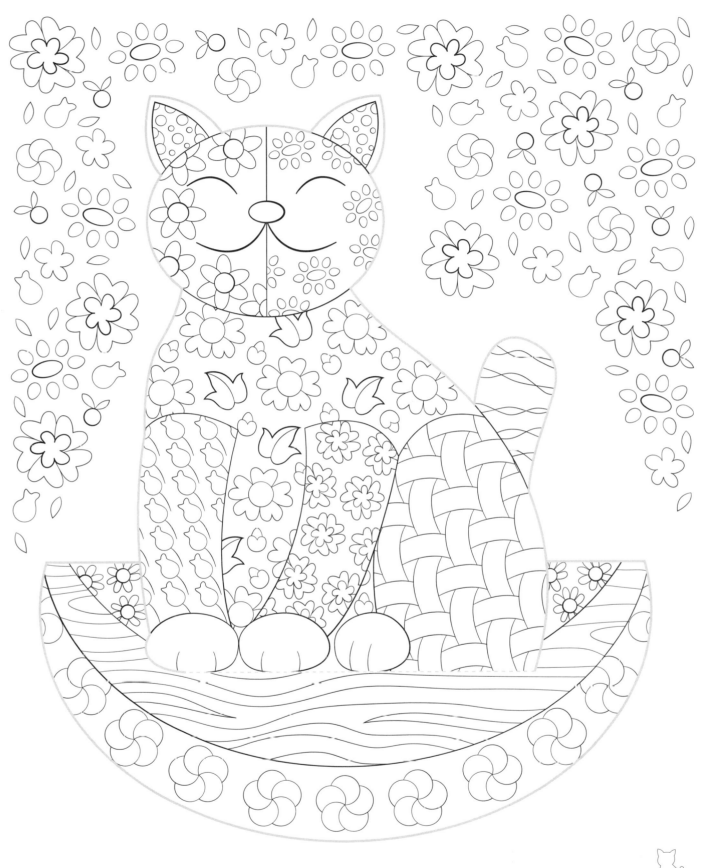

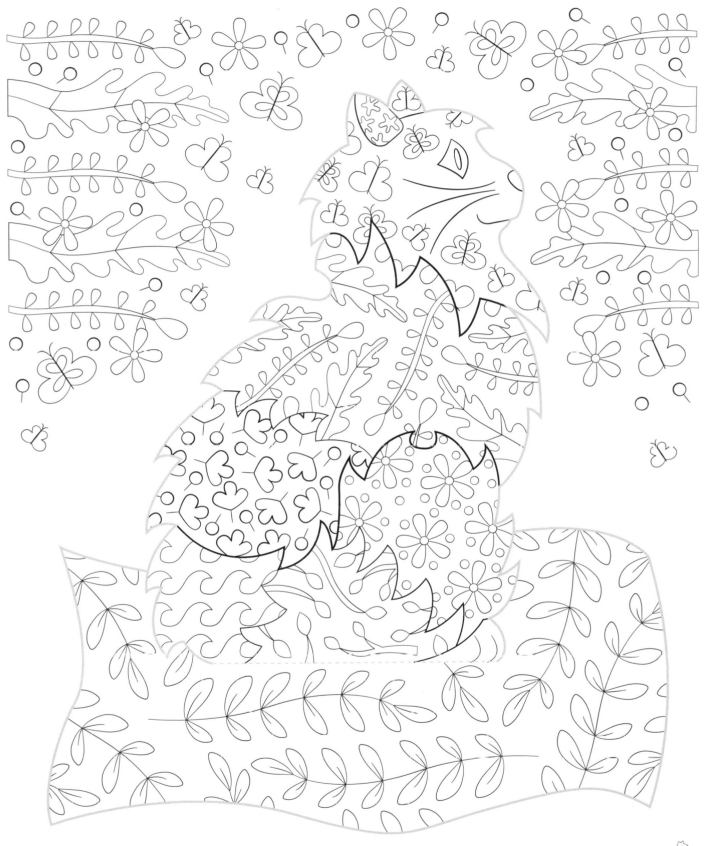

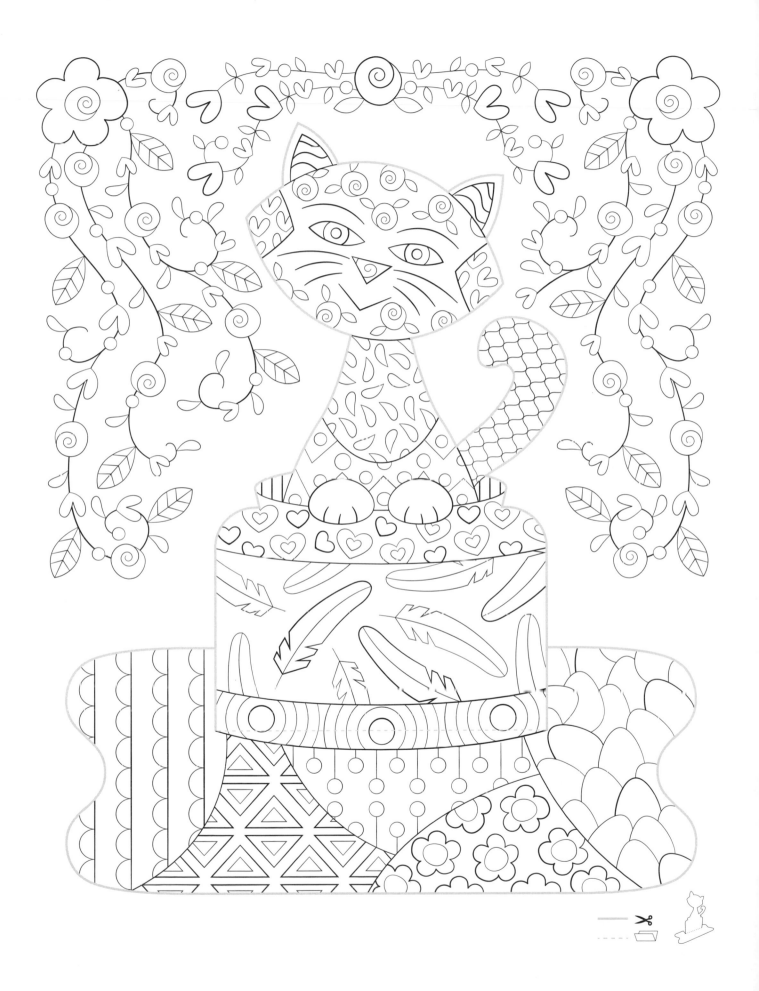

22

22

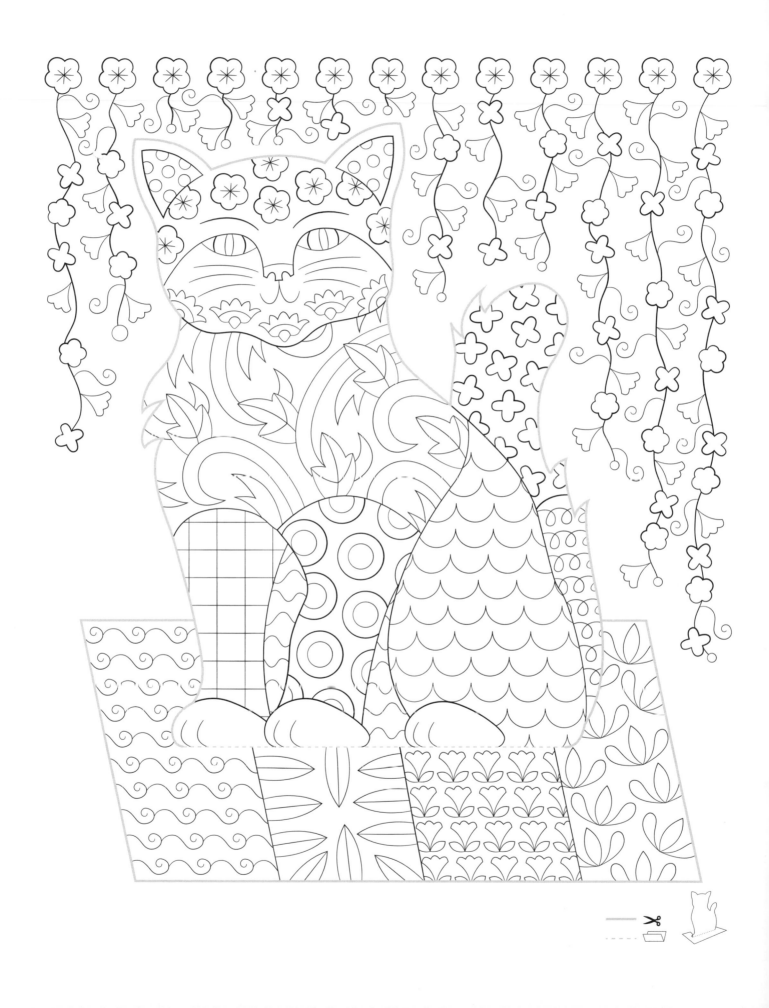

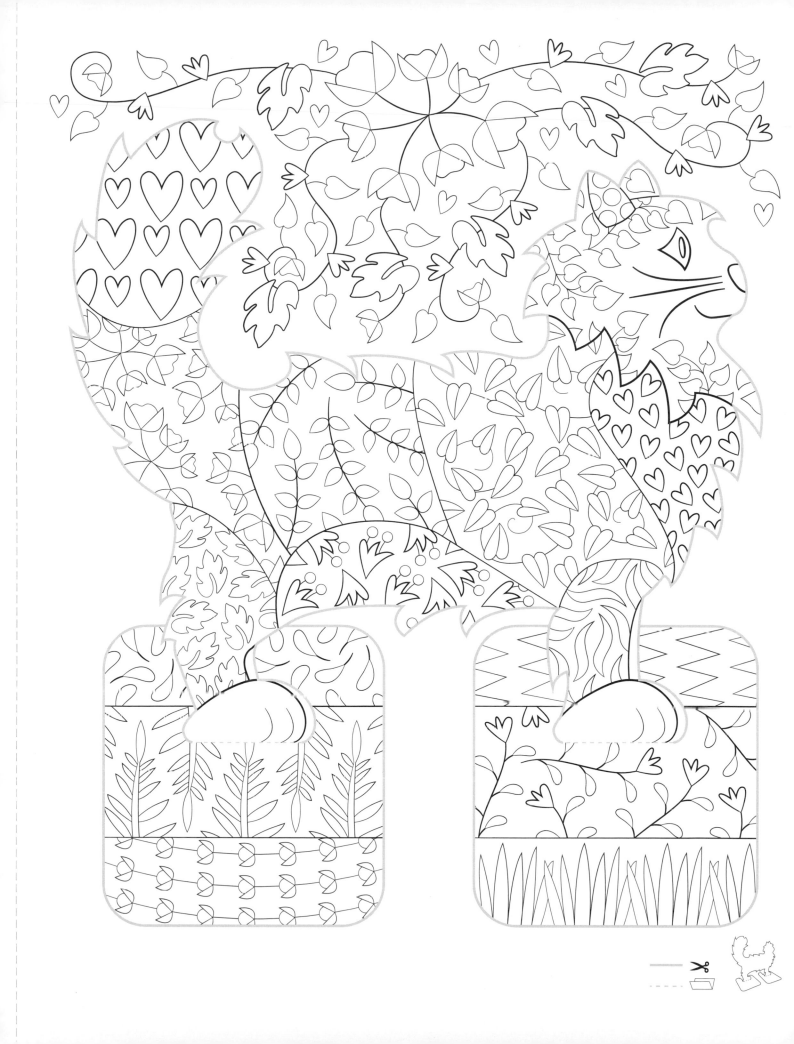

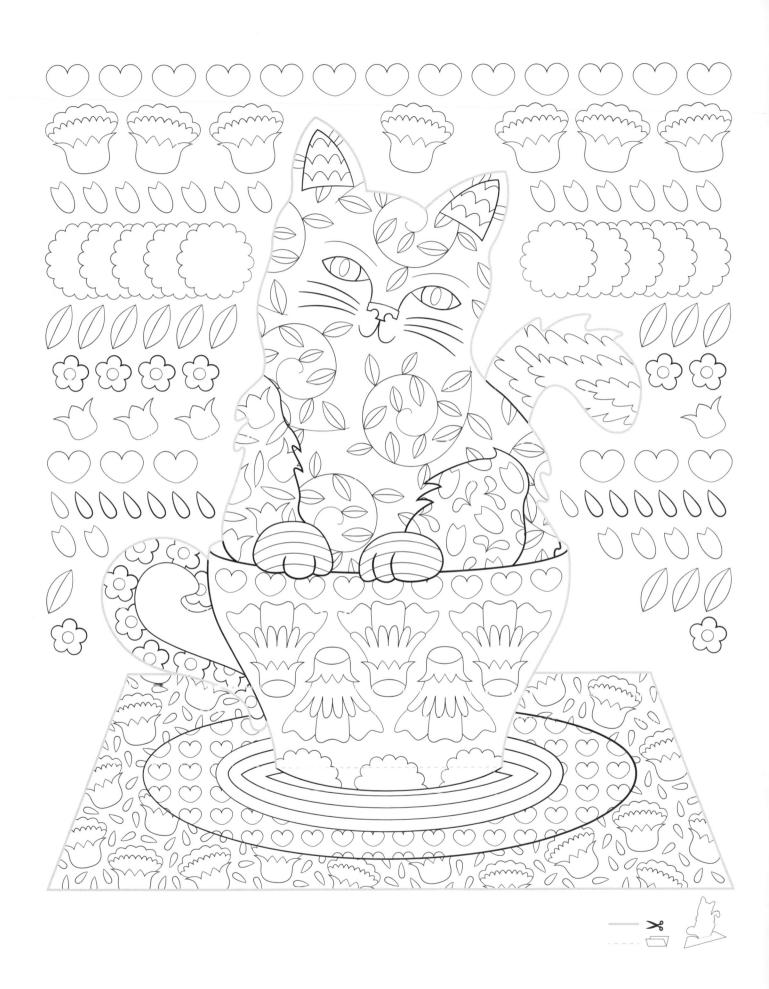

←———— 25

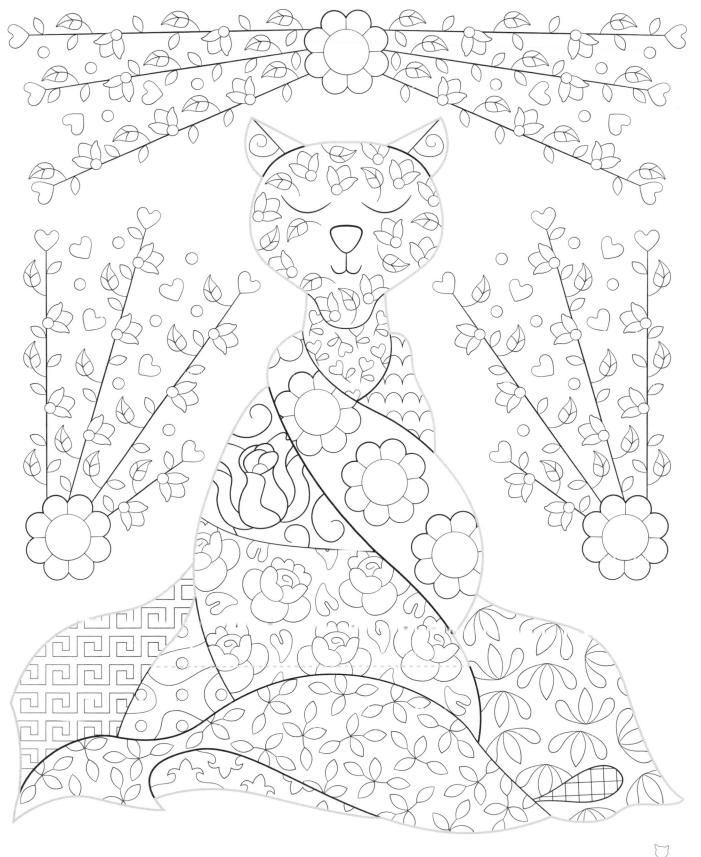

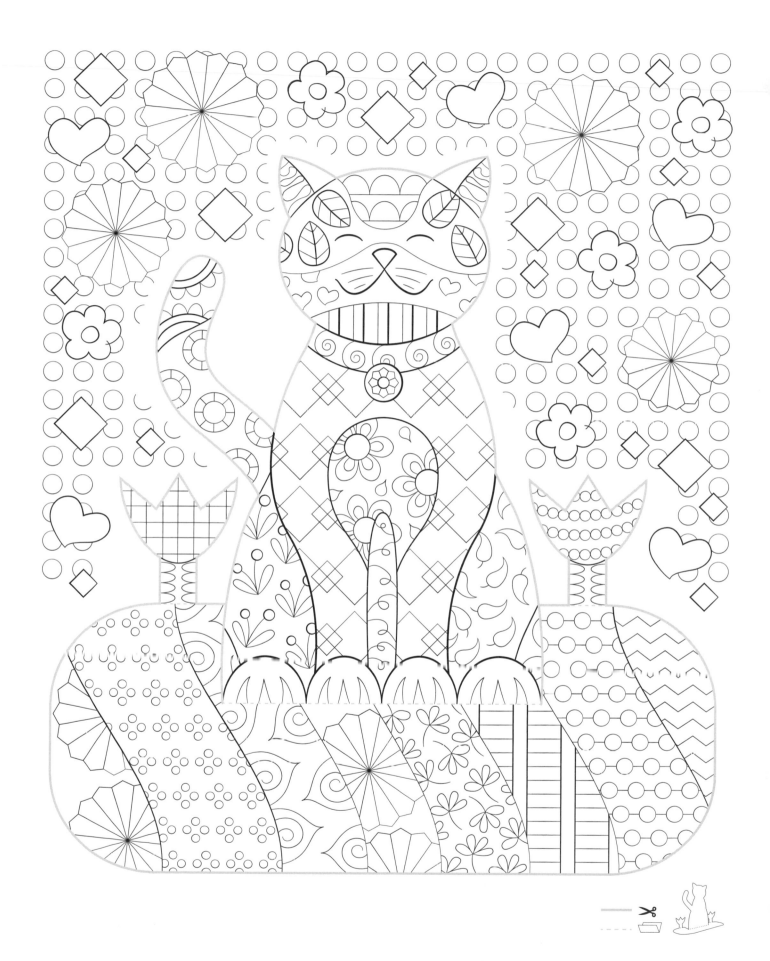

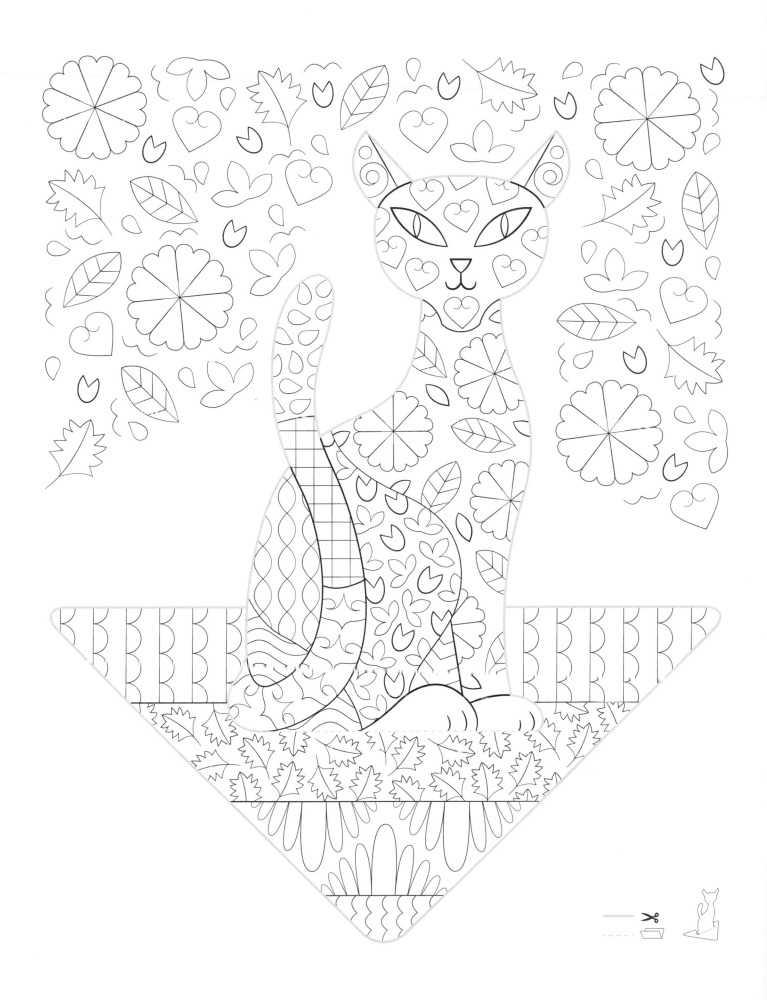

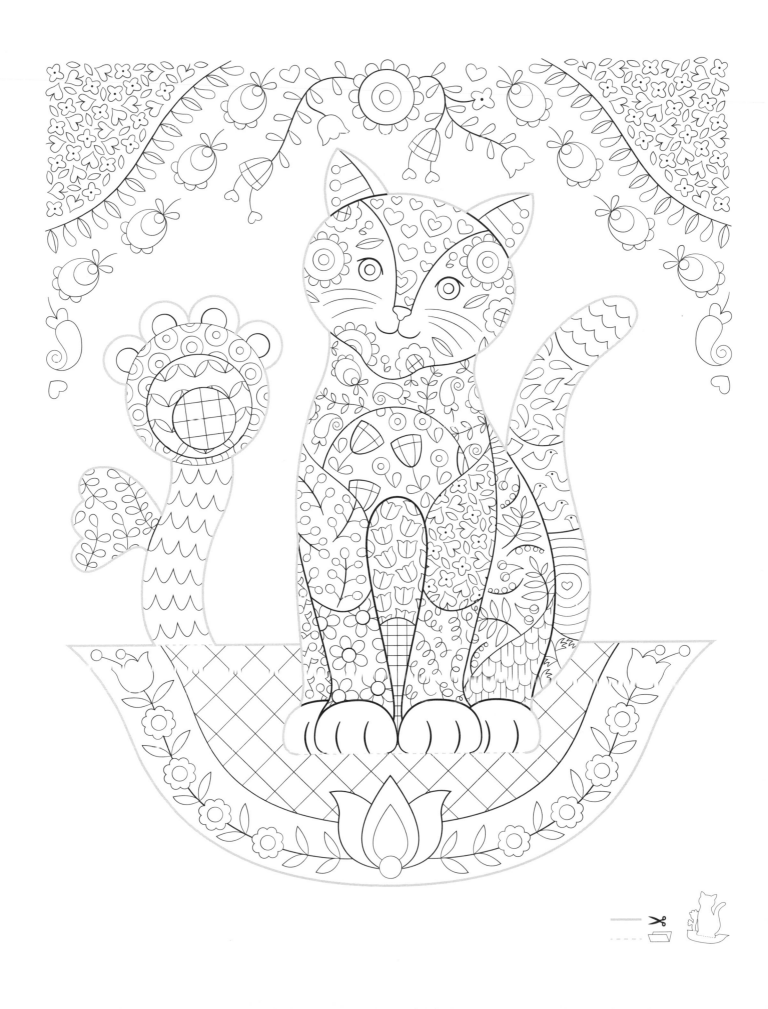

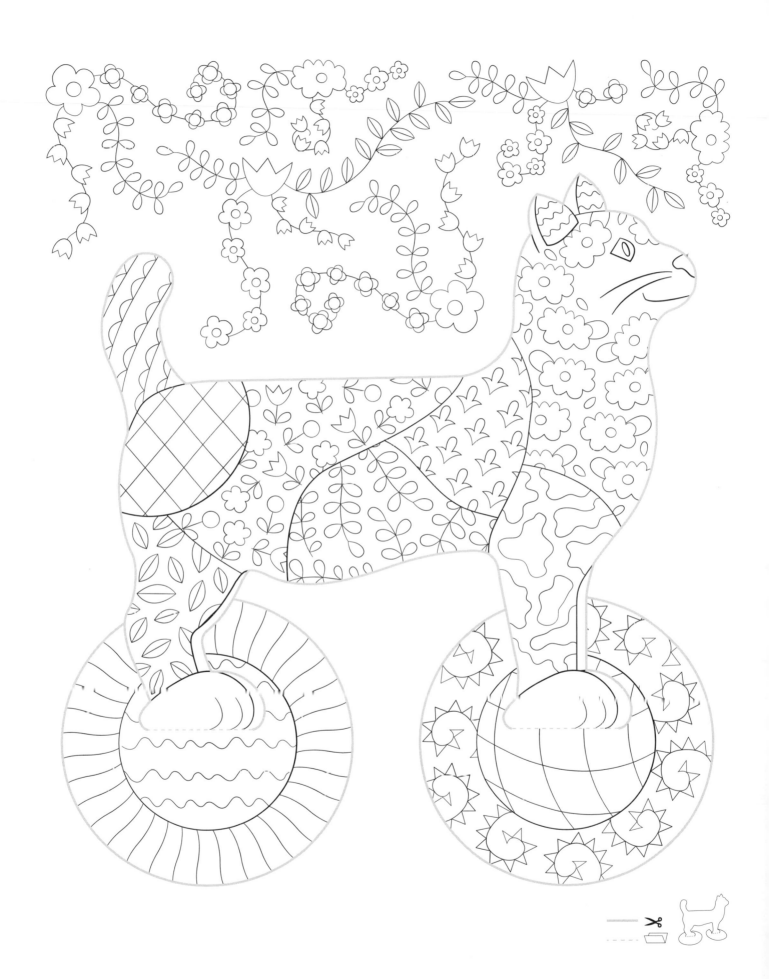